MEN
&
CATS

MEN
&
CATS

Marie-Eva Gatuingt *and* Alice Chaygneaud

B⊞XTREE

First published in the USA by Perigee, an imprint of Penguin Random House LLC

First published in the UK 2015 by Boxtree
an imprint of Pan Macmillan
20 New Wharf Road, London N1 9RR
Associated companies throughout the world
www.panmacmillan.com

ISBN 978-0-7522-6580-3

1 3 5 7 9 8 6 4 2

A CIP catalogue record for this book is available from the British Library.

Printed and bound in Italy

Visit **www.panmacmillan.com** to read more about all our books
and to buy them. You will also find features, author interviews and
news of any author events, and you can sign up for e-newsletters
so that you're always first to hear about our new releases.

Since we started our Tumblr, *Des Hommes et des Chatons,* in 2013, thousands of fans have discovered the allure of pairing sexy men with cute cats in strikingly similar poses. Now we have combined the crème de la crème into one volume with fifty never-before-seen man and kitty couples.

Men & Cats will remind you that your favourite things are even better when paired together.

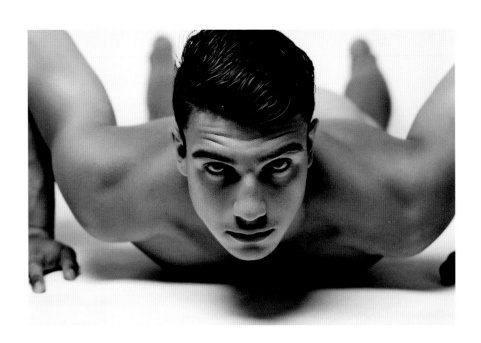

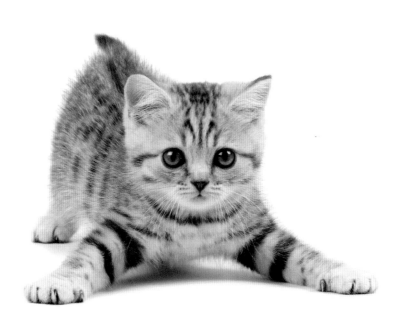

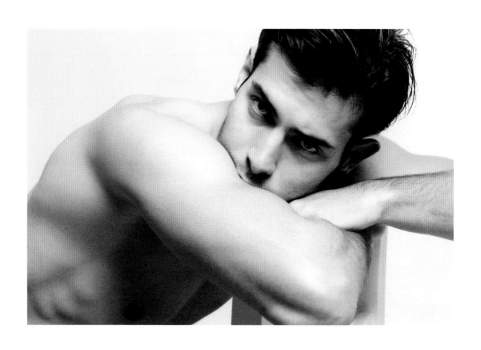

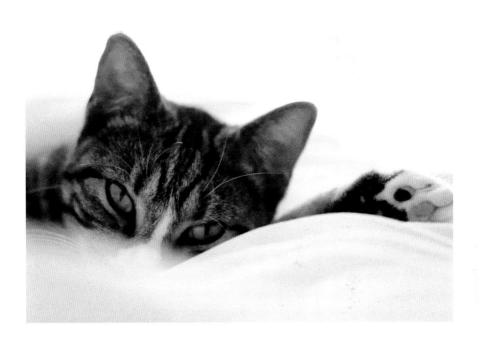

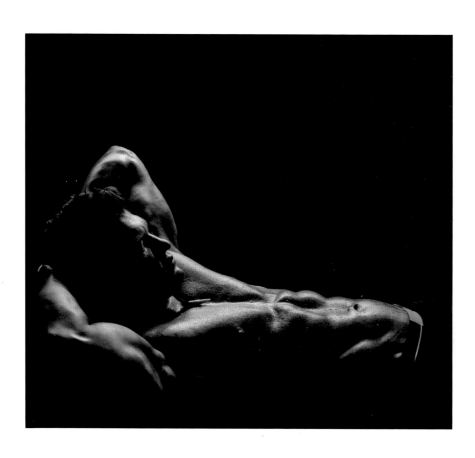

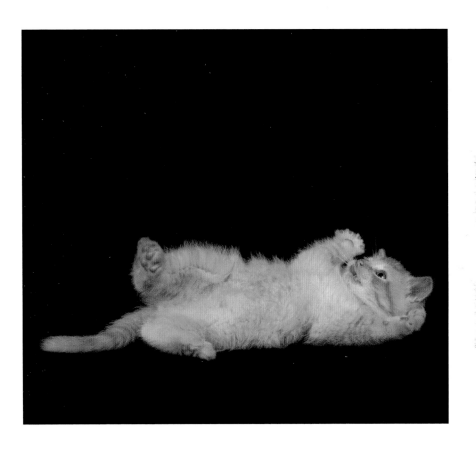

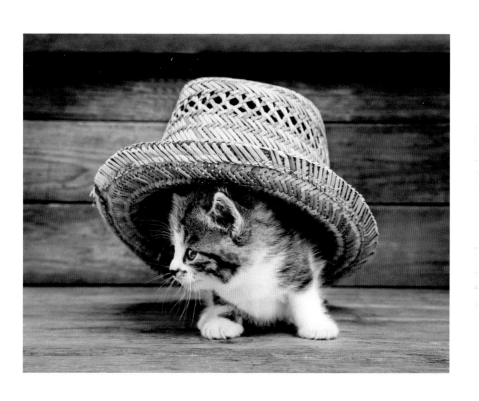

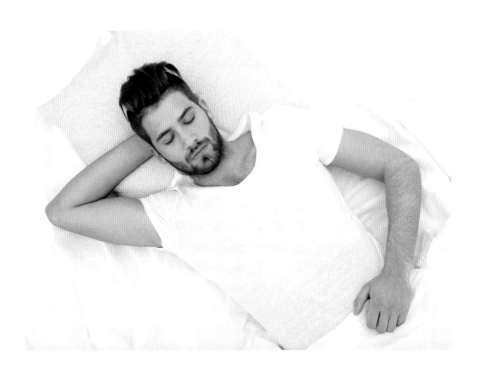

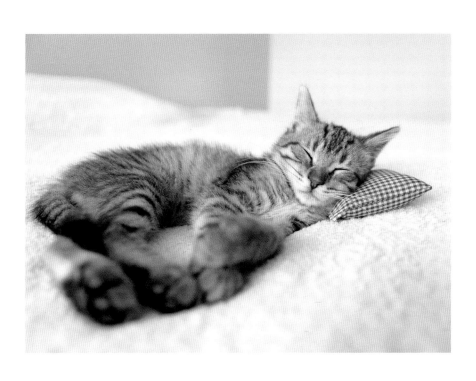

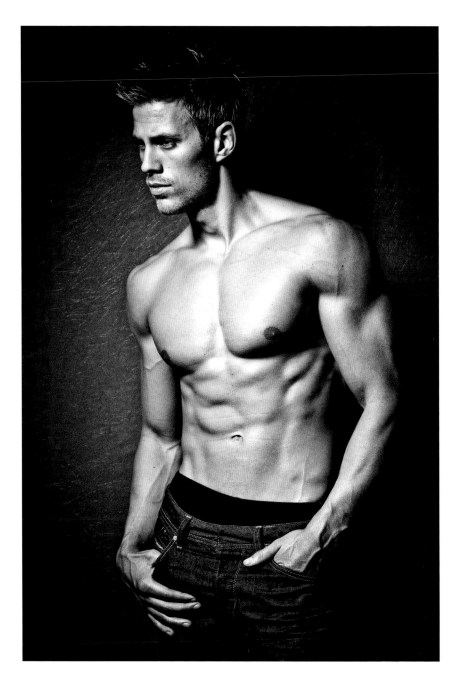

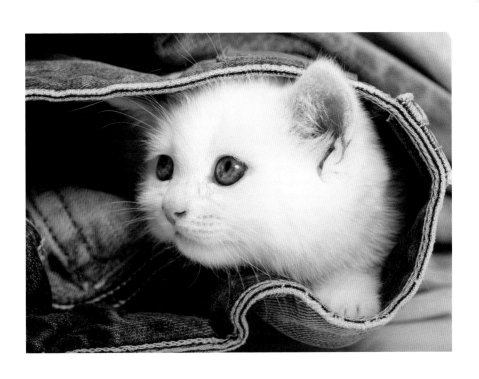

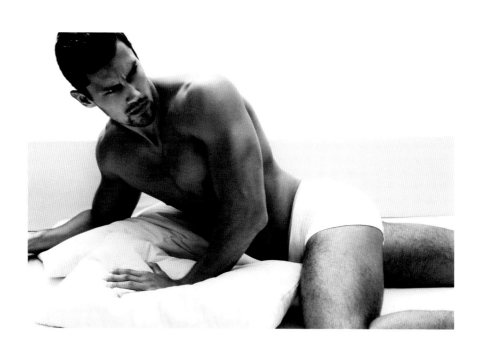

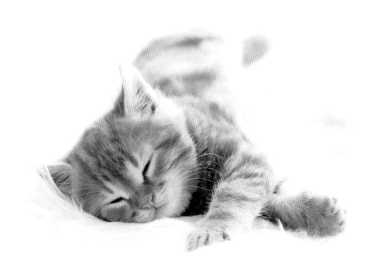

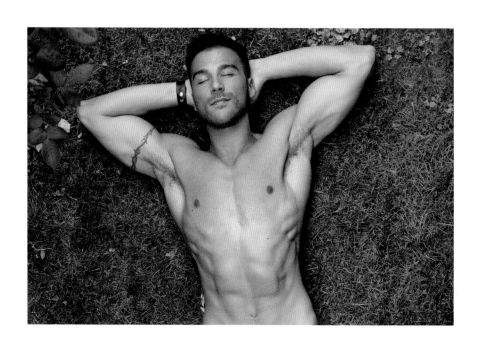

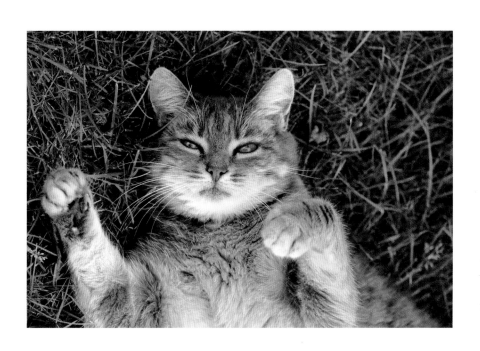

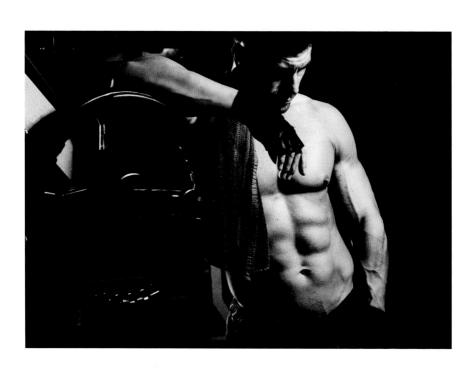

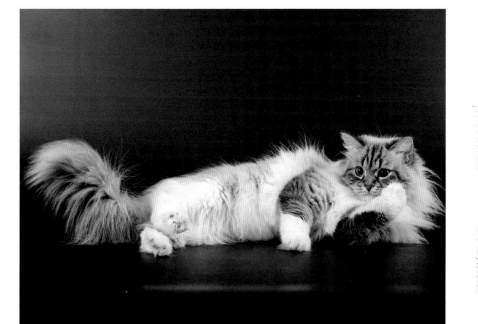

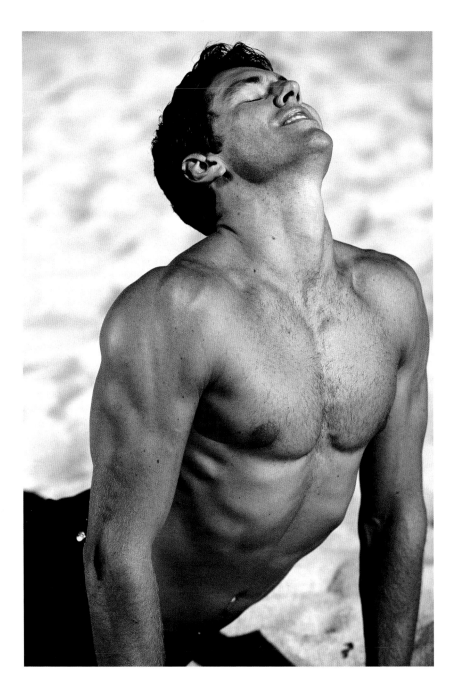

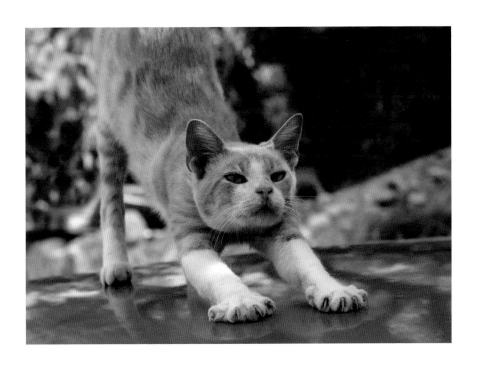

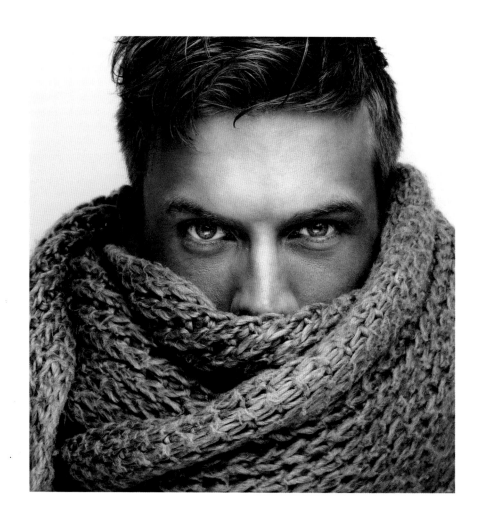

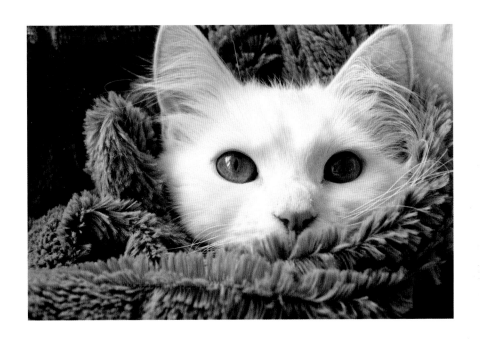

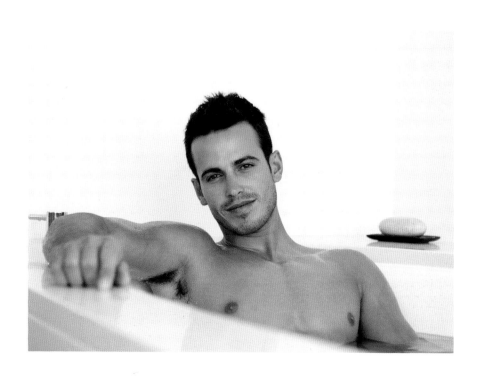

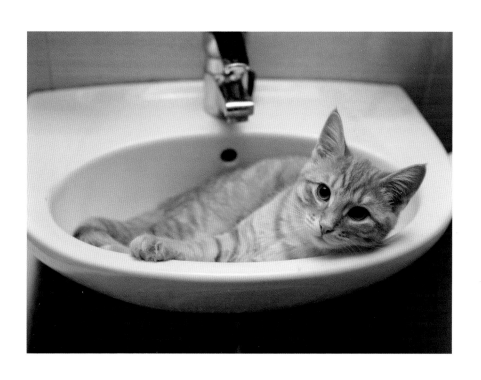

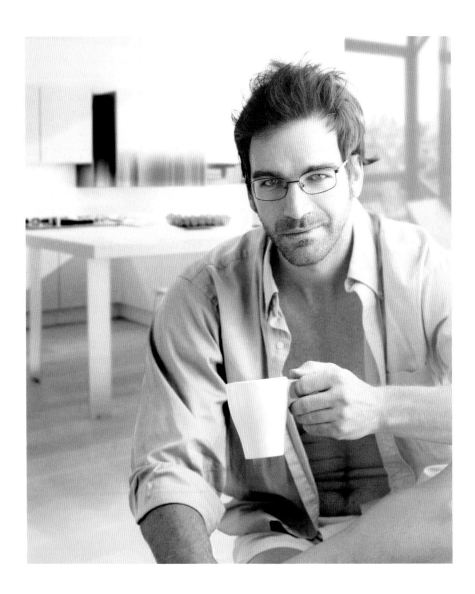

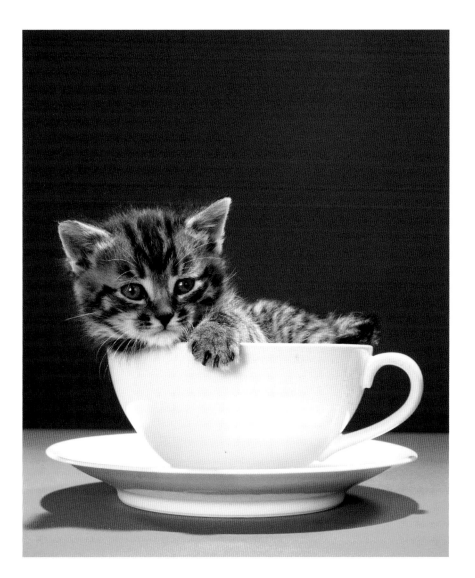

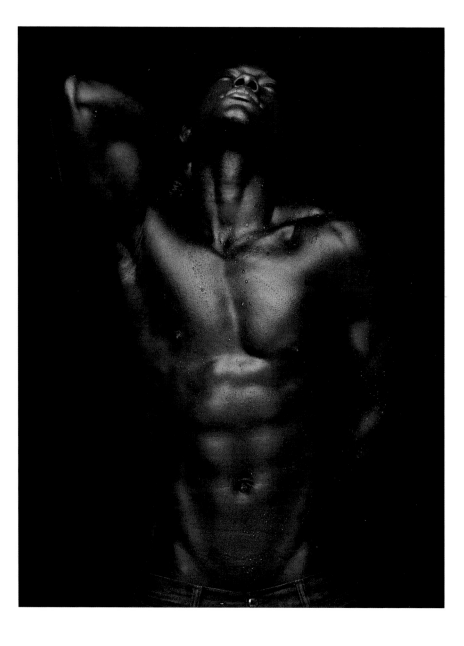

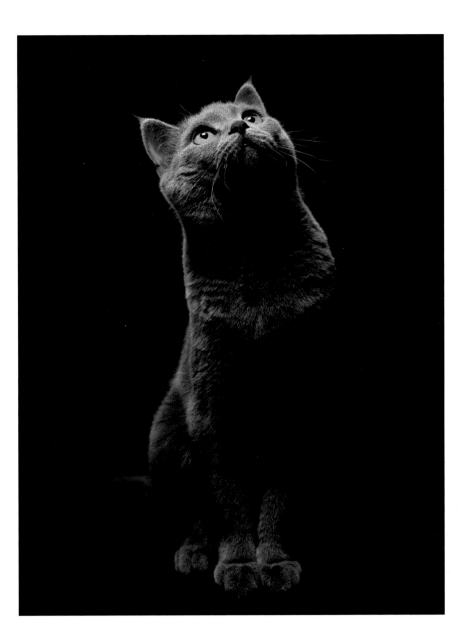

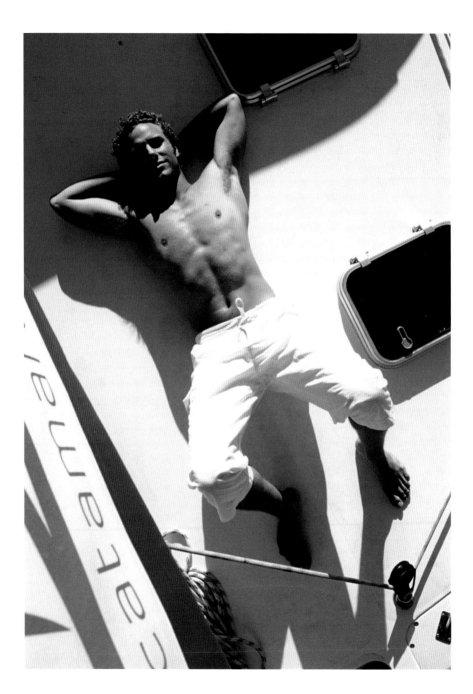

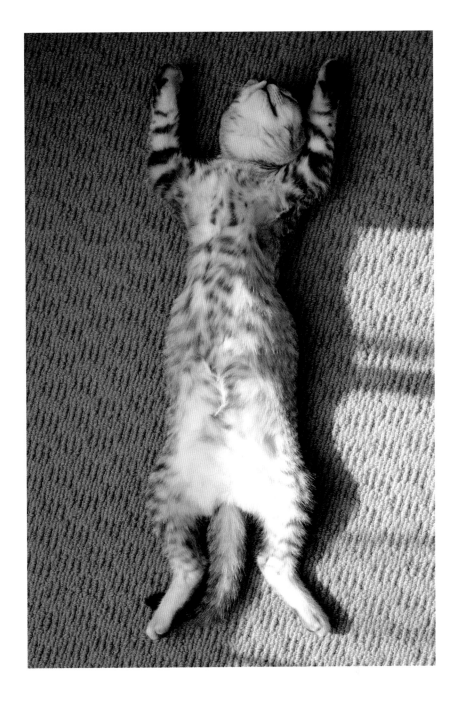

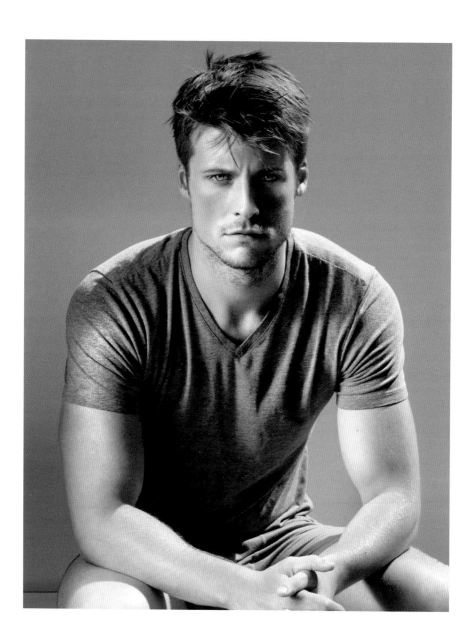

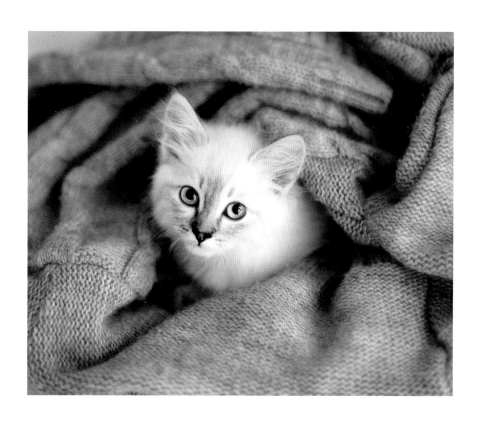

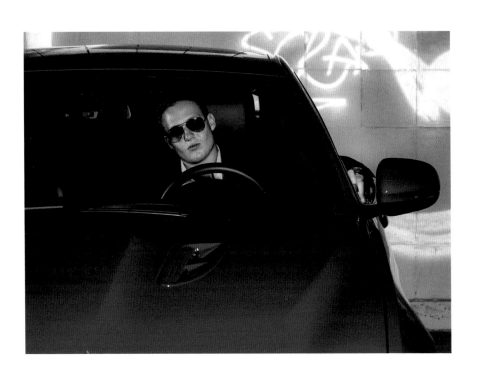

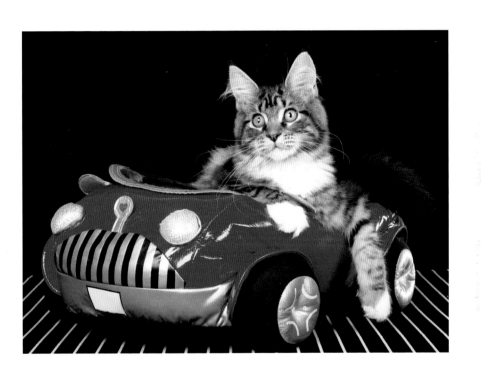

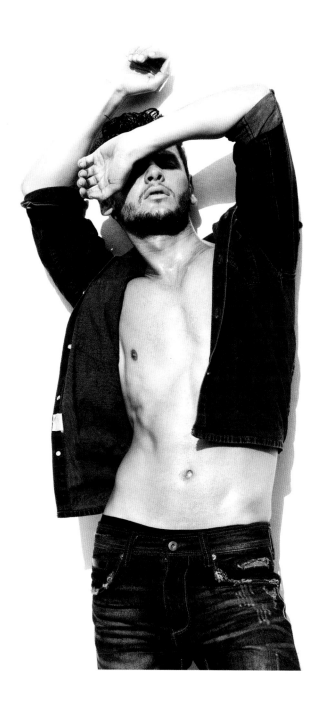

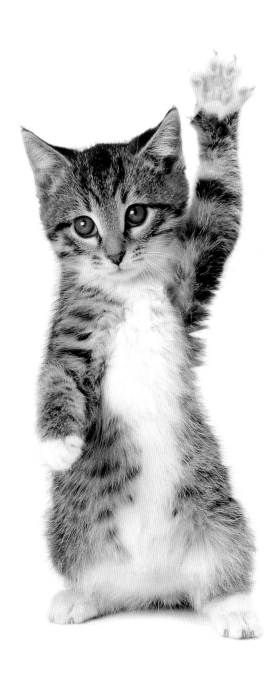

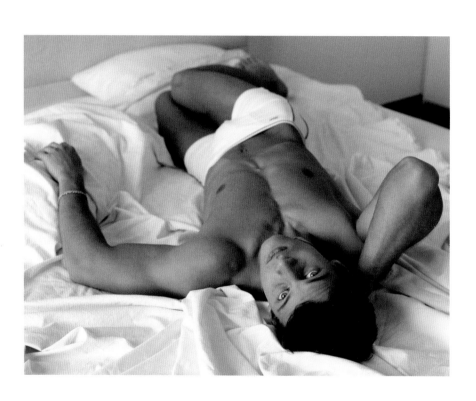

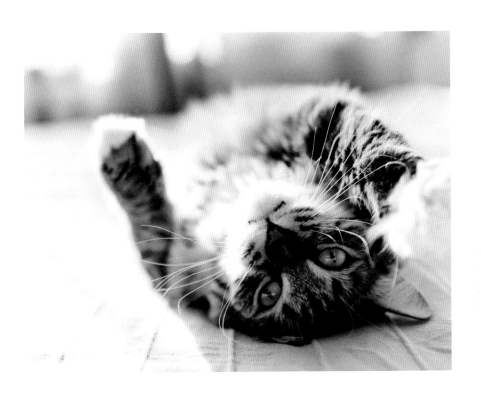

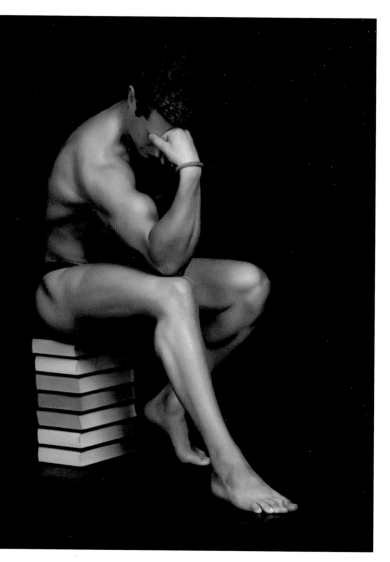

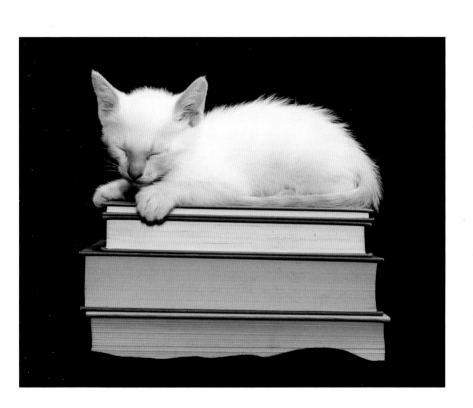

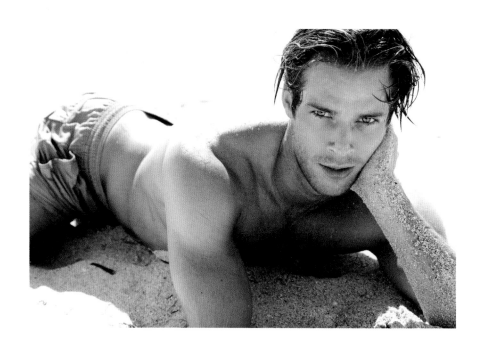

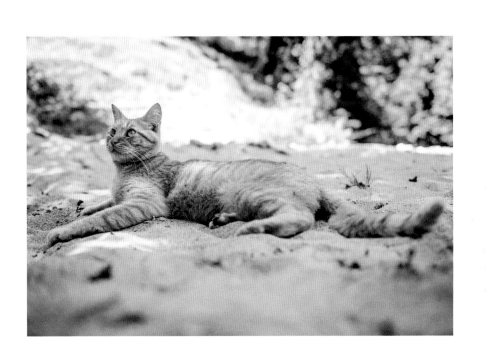

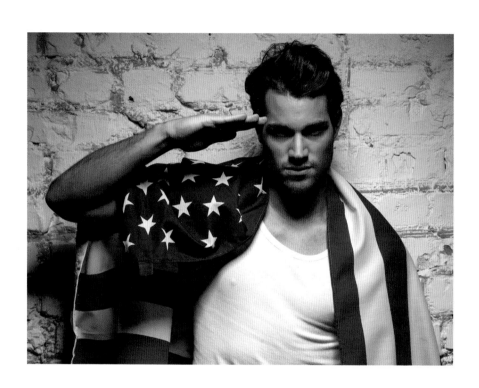

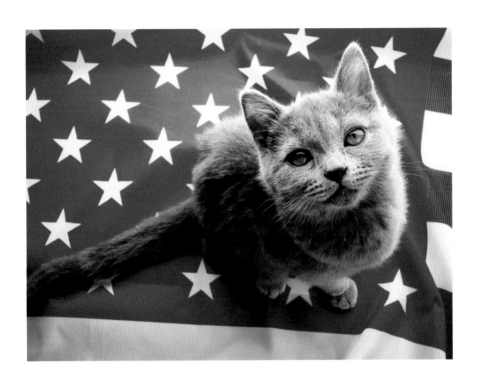

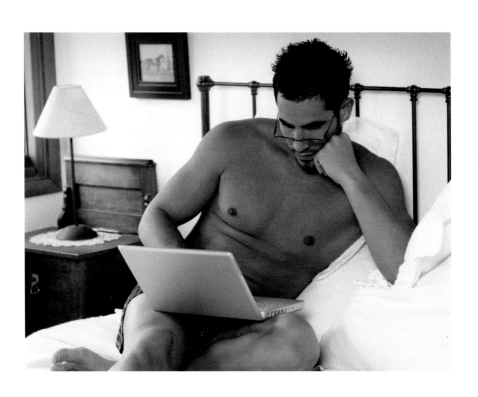

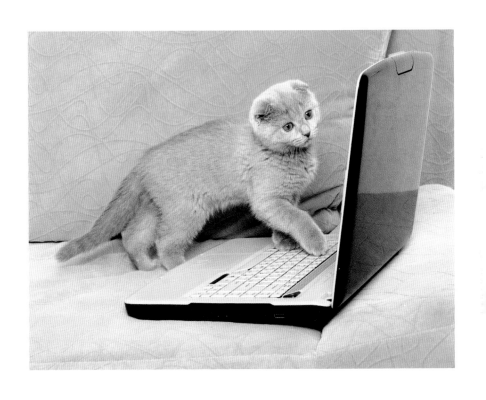

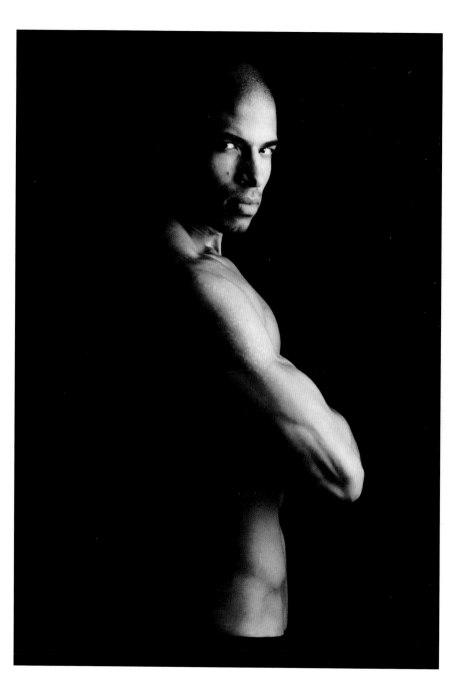

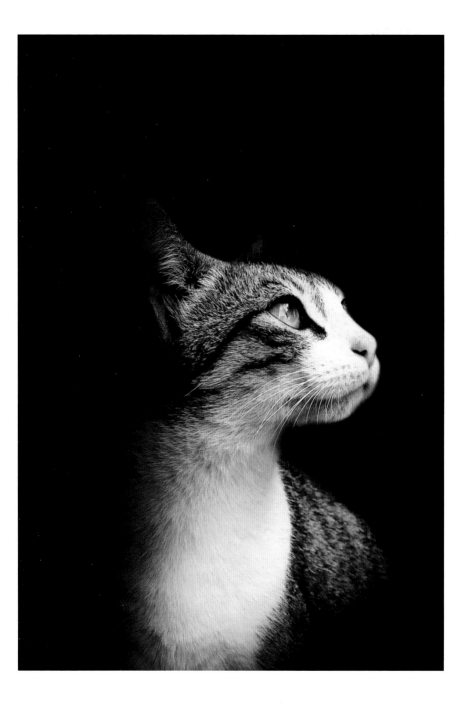

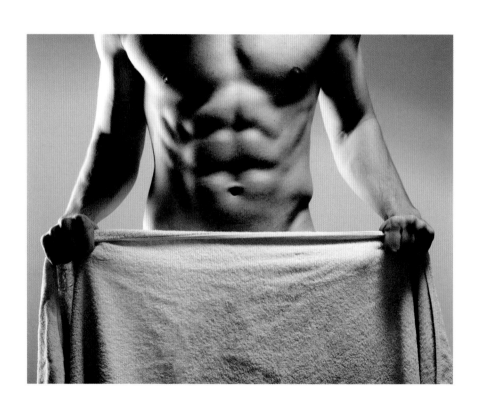

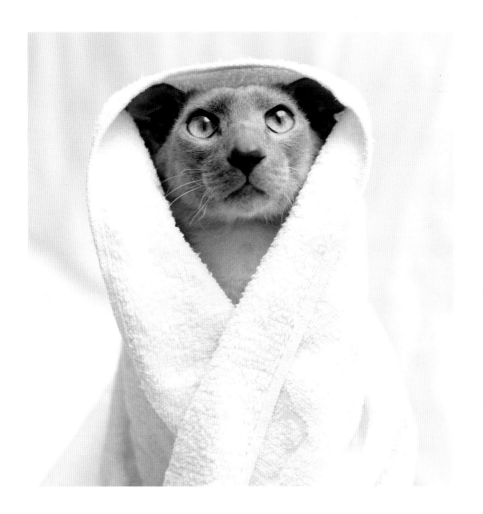

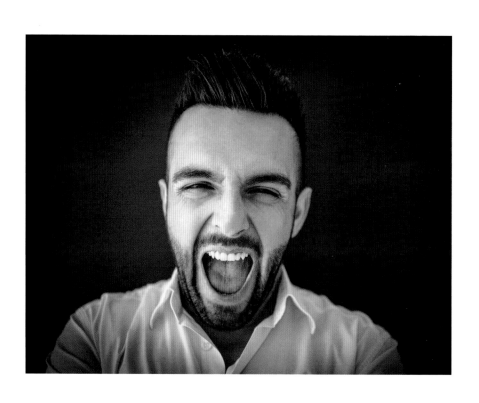

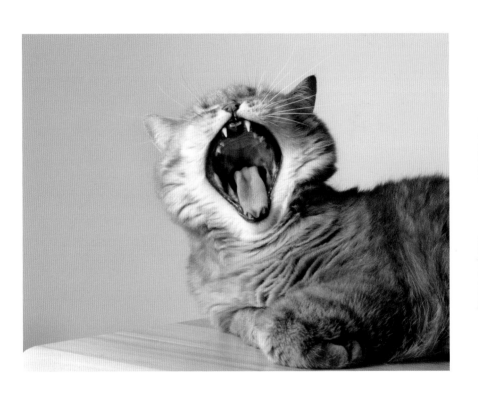

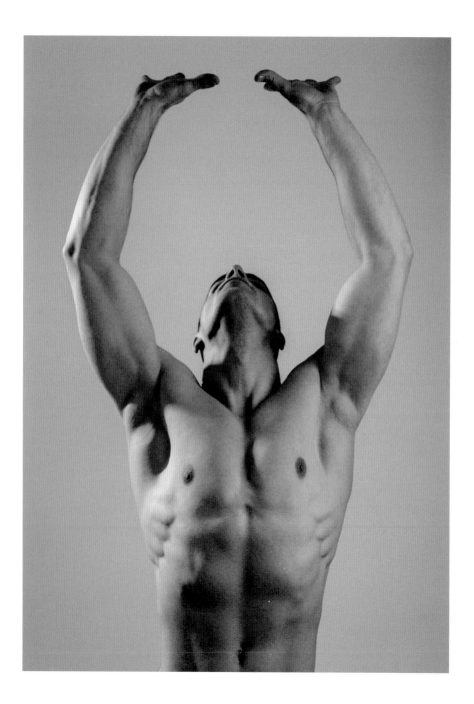

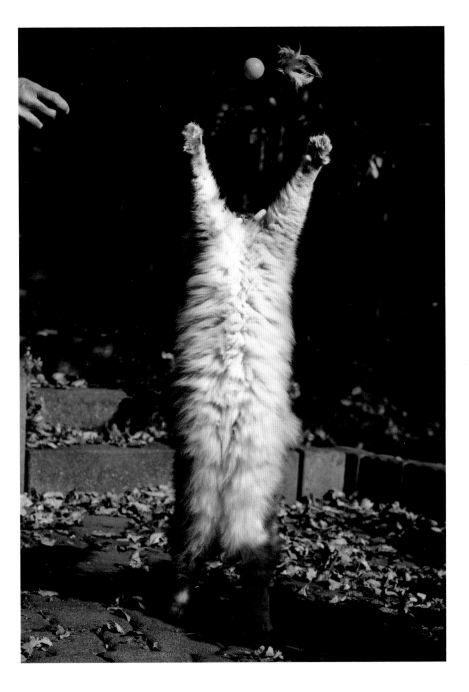

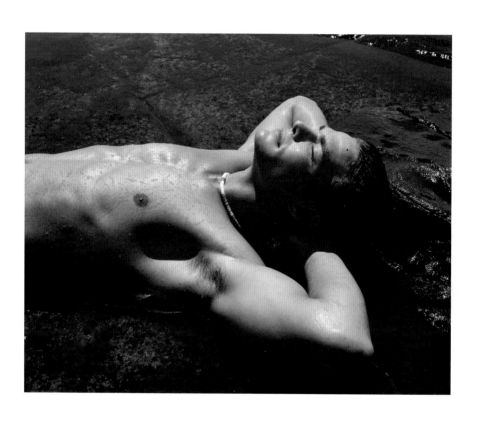

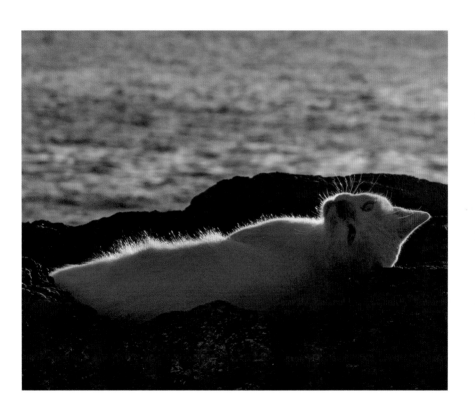

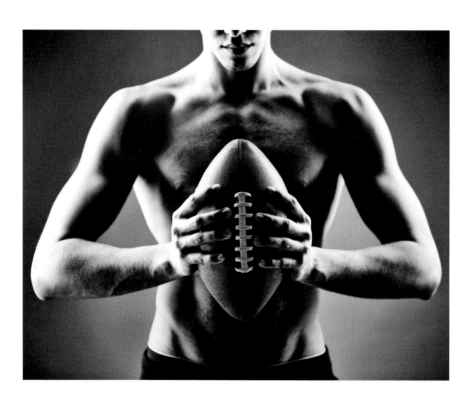

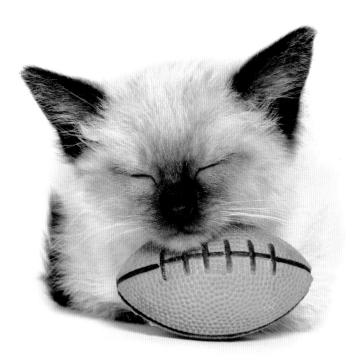

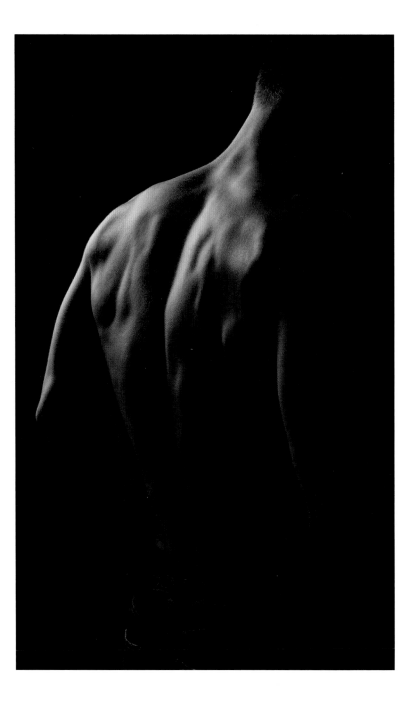

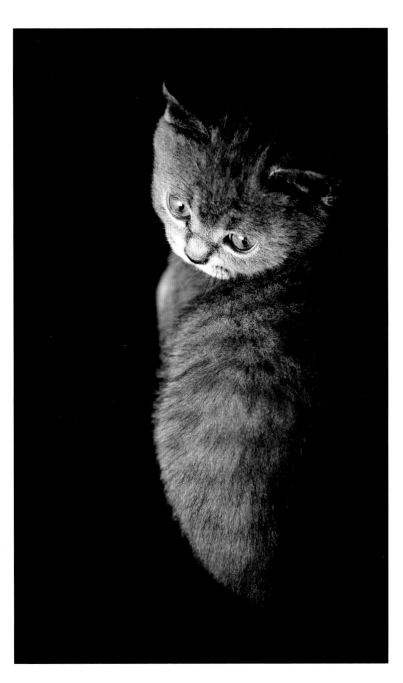

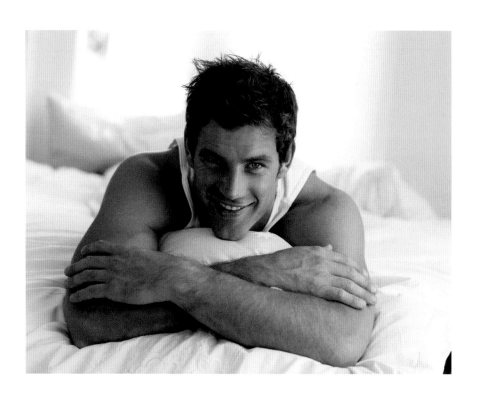

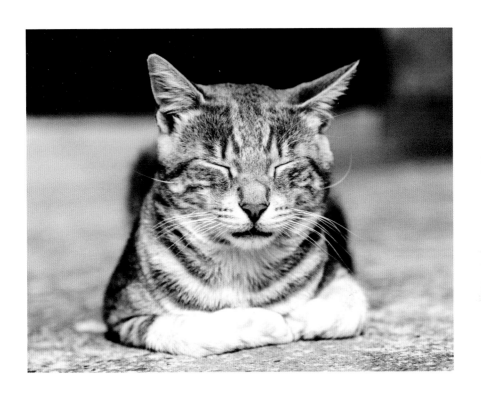

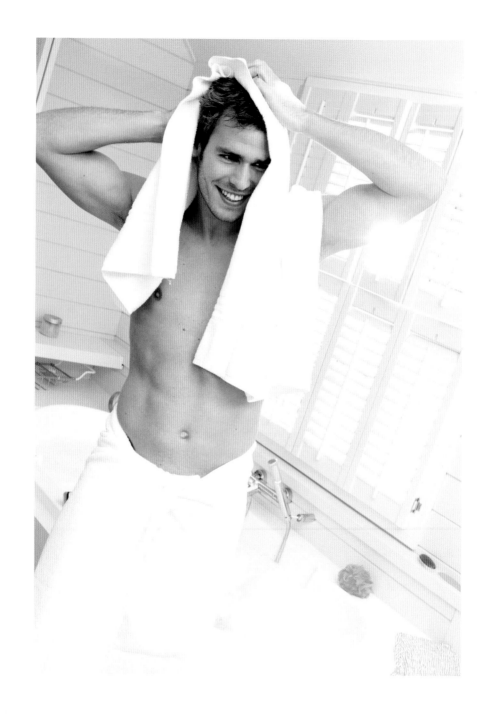

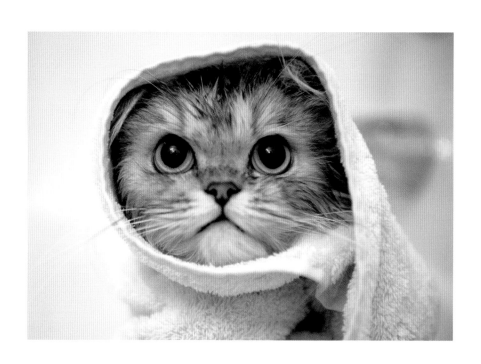

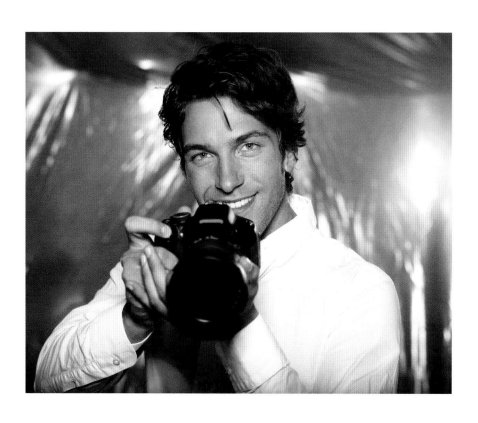

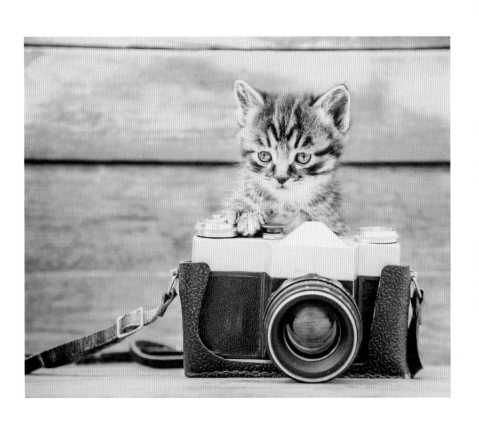

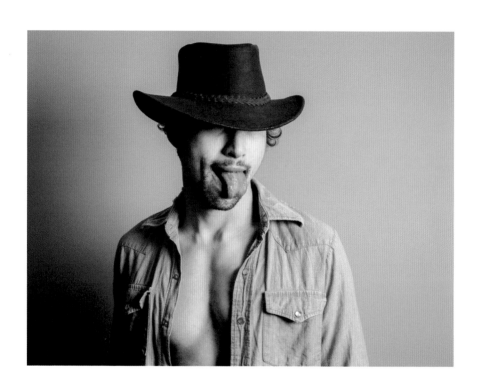

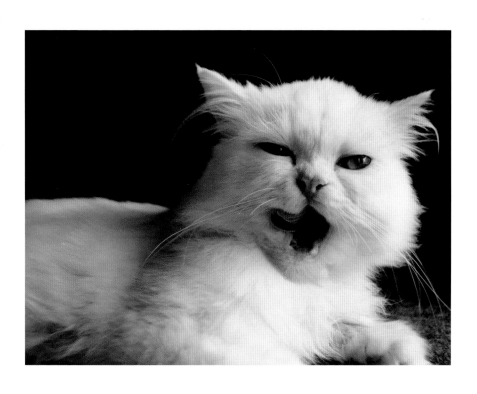

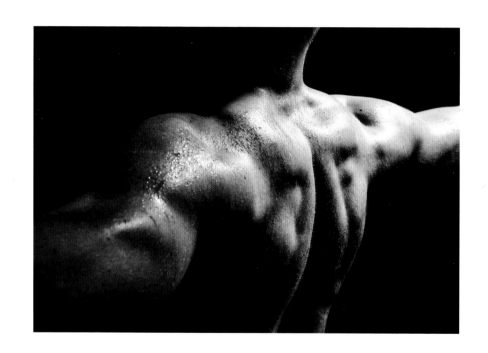

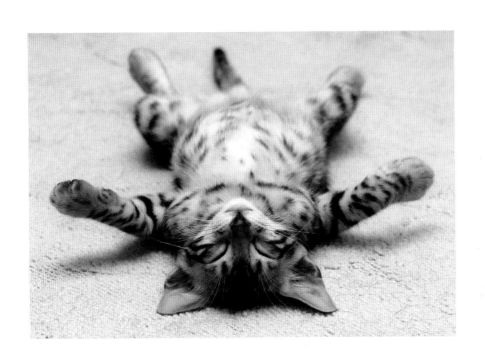

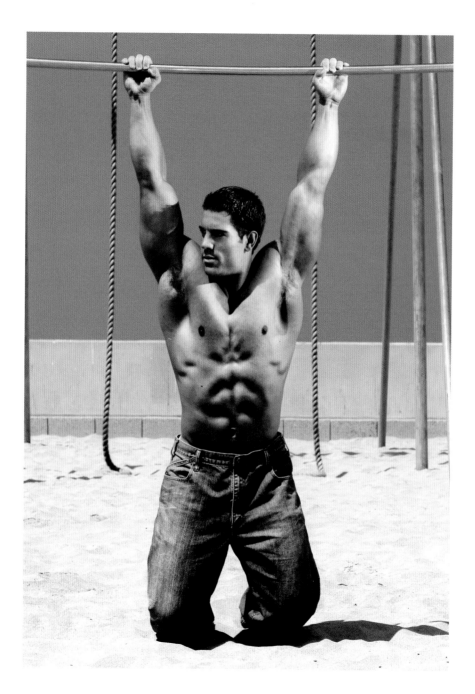

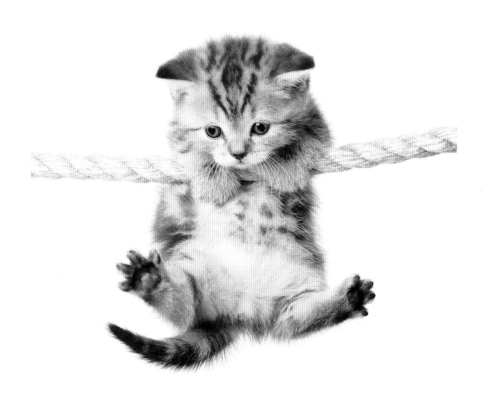

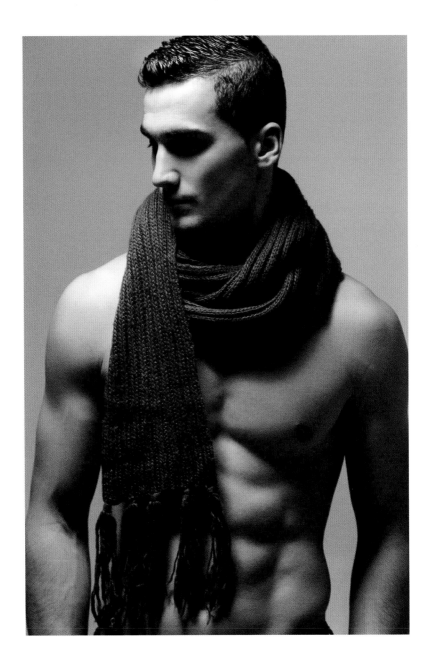

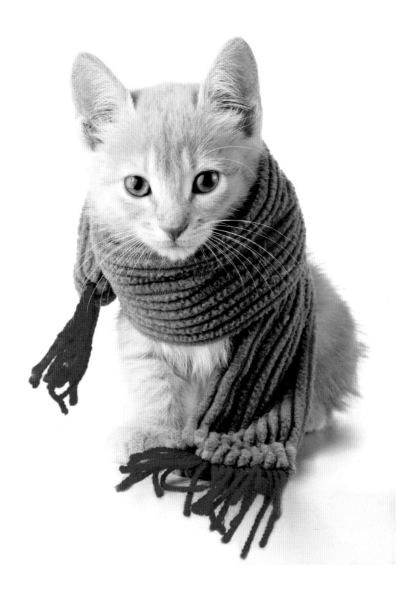

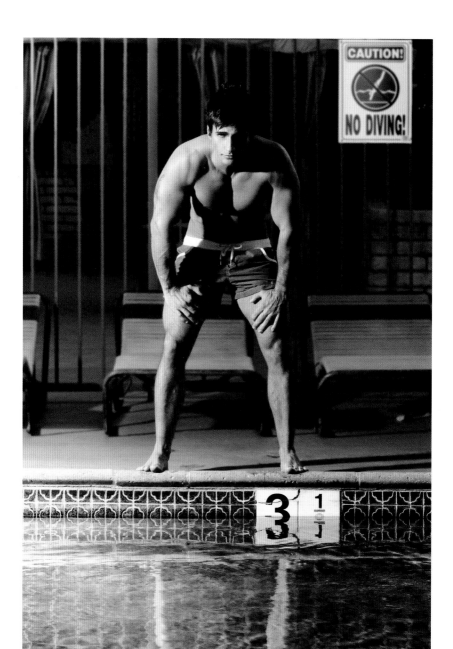

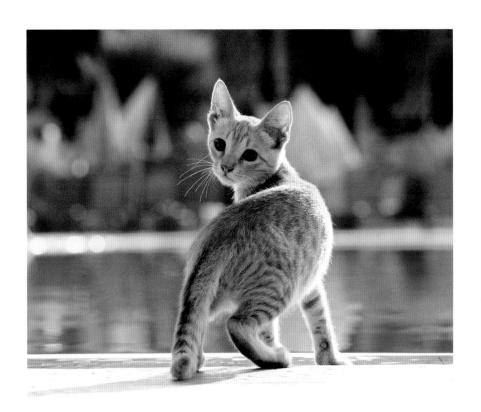

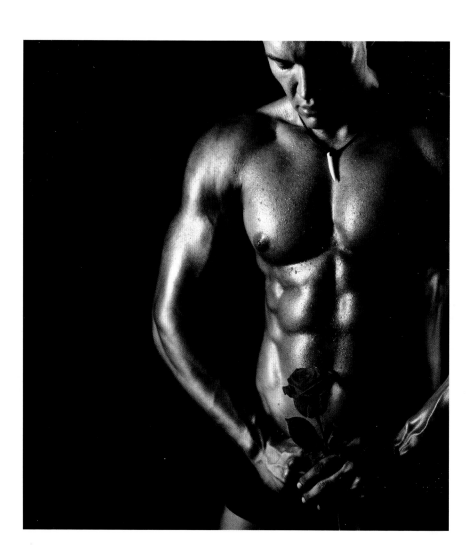

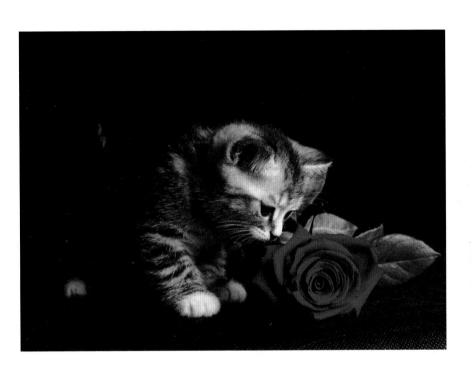

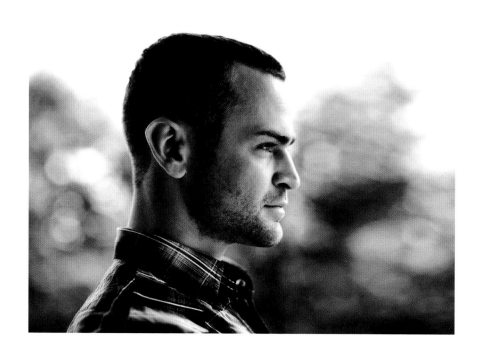

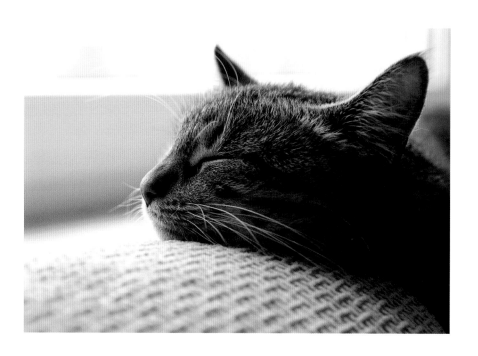

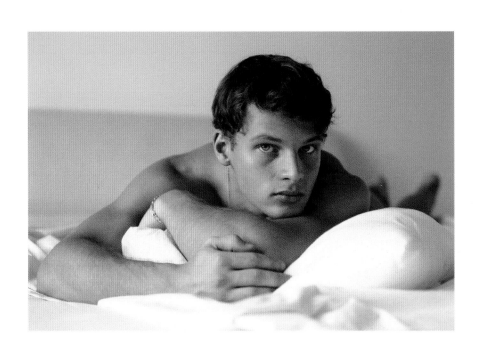

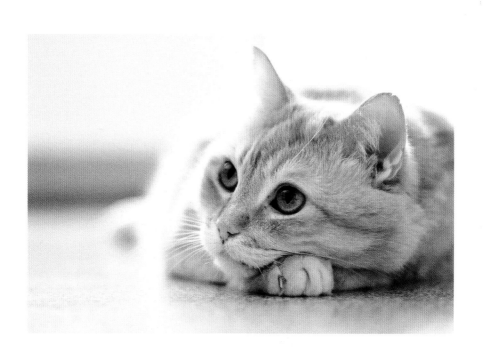

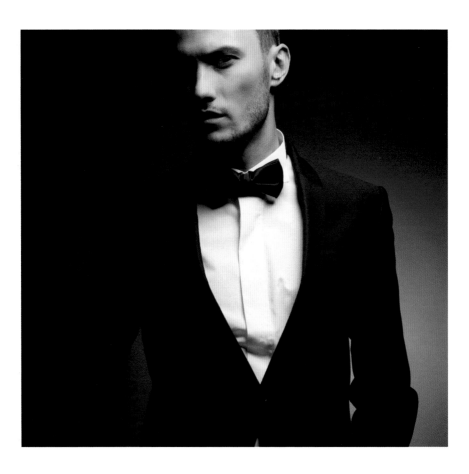

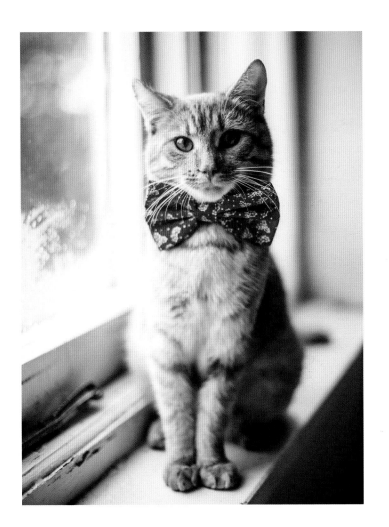

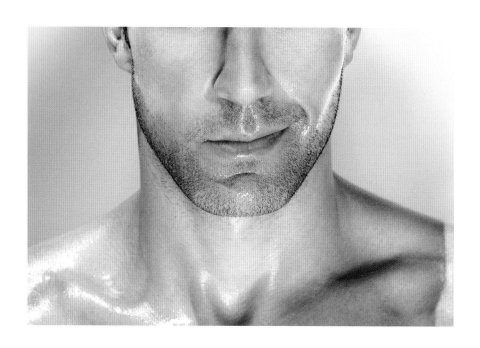

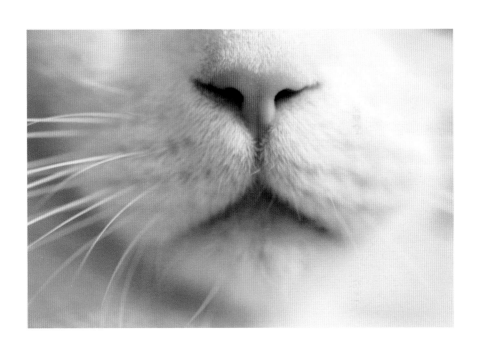

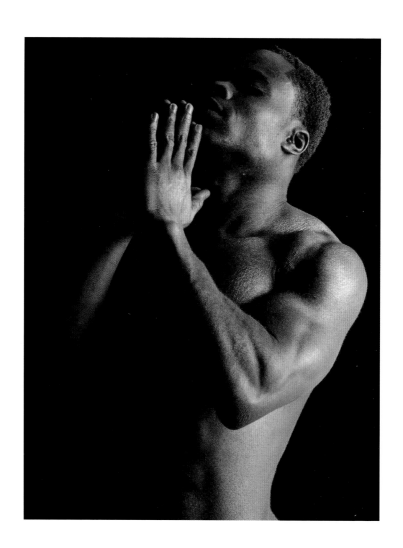

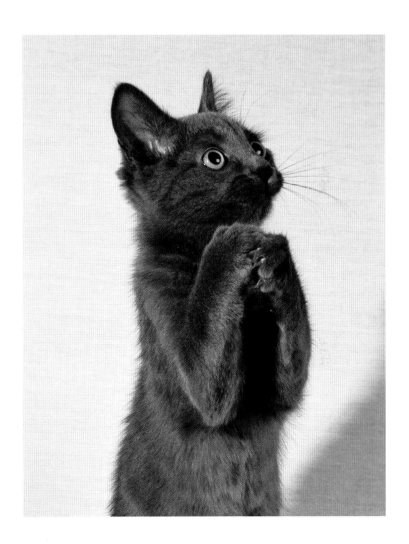

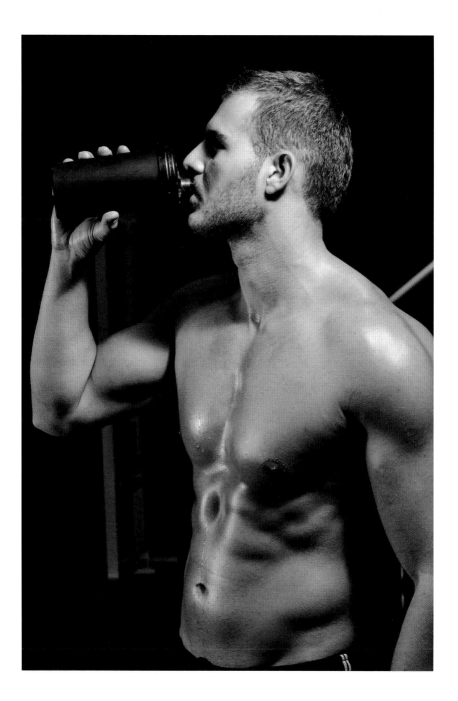

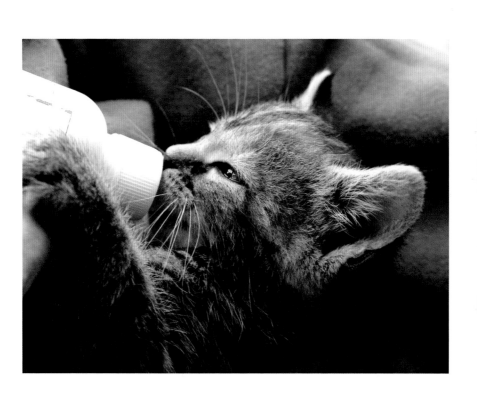

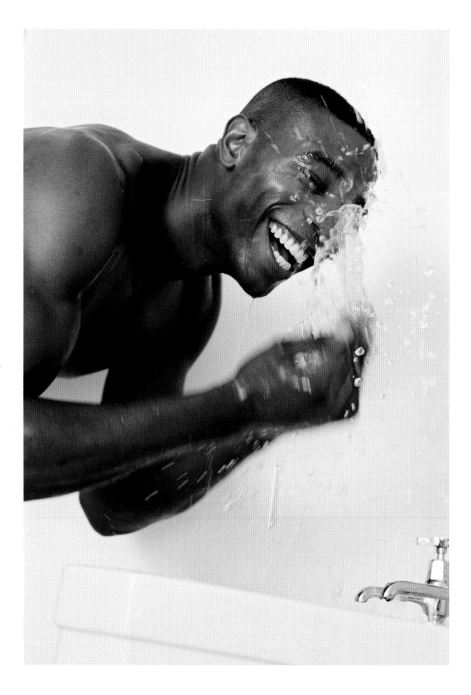

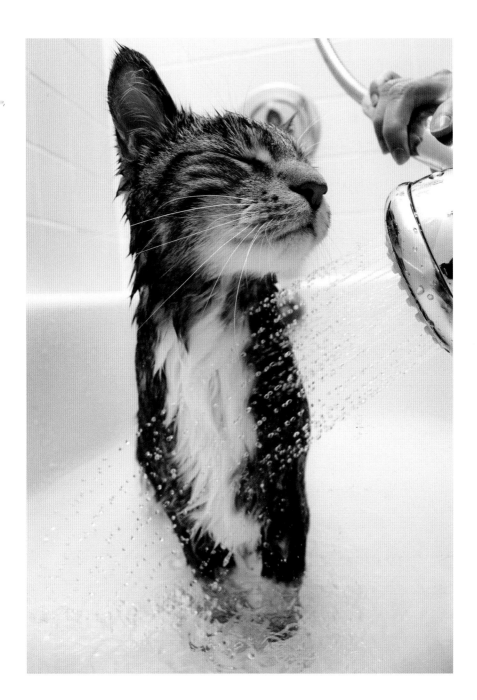

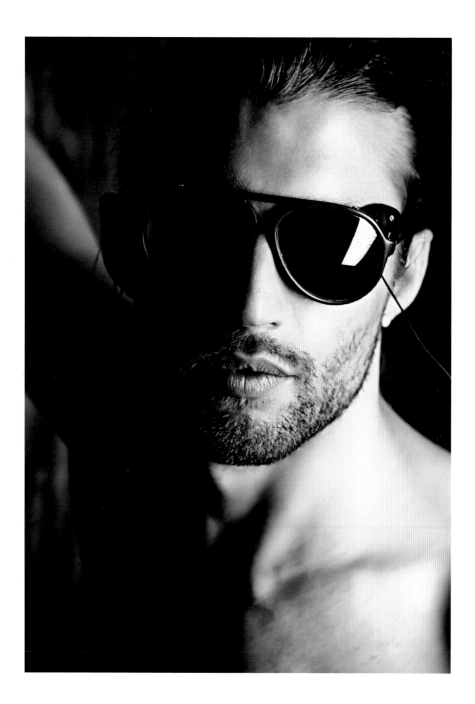

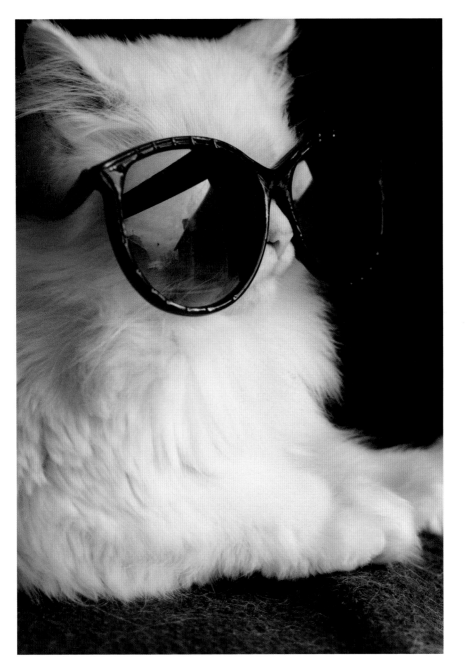

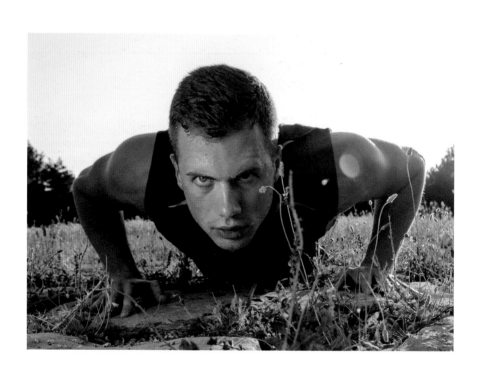

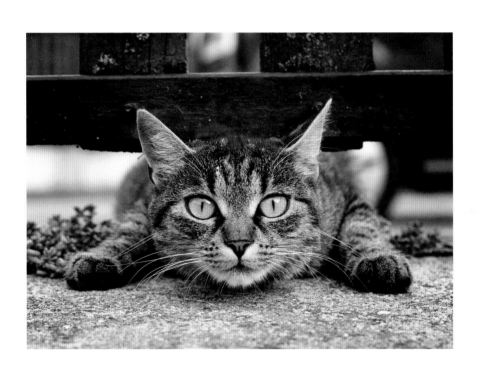

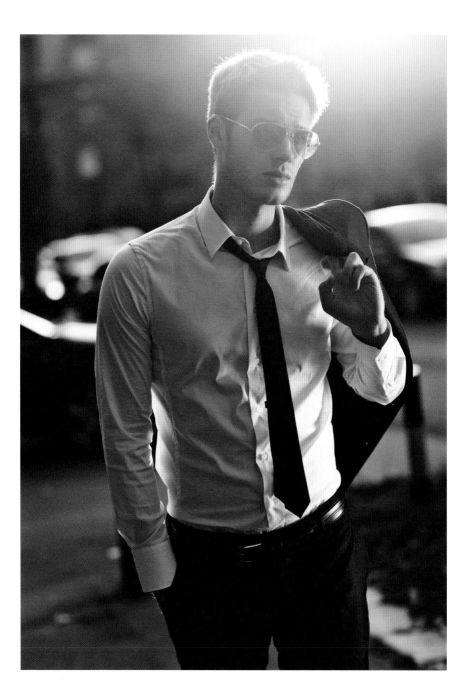

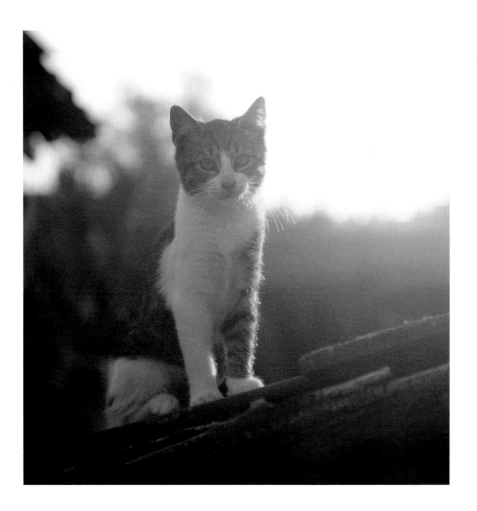

ACKNOWLEDGEMENTS

We would like to thank our respective men, Michael and Simon; our pets, Diego and Crapule; and our family and friends for their daily support.

ABOUT THE AUTHORS

Marie-Eva Gatuingt and **Alice Chaygneaud** are the founders of the popular Tumblr *Des Hommes et des Chatons*, which brings their two favourite things together: kittens and men. Every day they post a pair of photos, one man and one cat, with a shared posture or attitude. Both cute and sexy, the Tumblr is a huge and international success. Both authors live in Paris, France.